THE PRINCESS AND THE PEA

BY HANS CHRISTIAN ANDERSEN

Golden Age of Illustration Series

POOK PRESS

POOK PRESS

Copyright © 2015 Pook Press
An imprint of Read Publishing Ltd.

Home Farm, 44 Evesham Road, Cookhill, Alcester,
Warwickshire, B49 5LJ

British Library Cataloguing-in-Publication Data.
A catalogue record for this book is available from the
British Library.

www.pookpress.co.uk

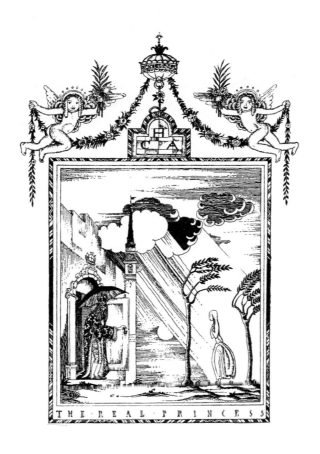

CONTENTS

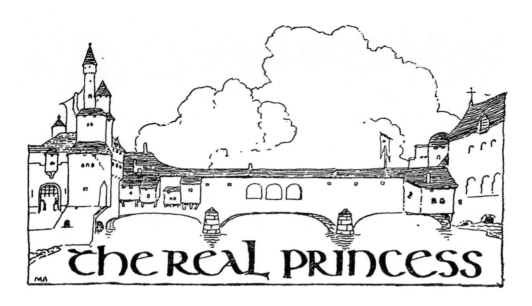

LIST OF ILLUSTRATIONS

Biography

of

HANS CHRISTIAN ANDERSEN

"First, you undergo such a terrible amount of suffering,
and then you become famous."

This quote, taken from Hans Christian Andersen's autobiography *The Fairy Tale of My Life* (1855), could serve as a one-sentence biography of the great writer. Before he achieved global fame as an author of children's literature on a par with Aesop and the Brothers Grimm, Andersen suffered three decades of toil, isolation and strife. Had it not been for his unwavering determination to become a professional writer, the literary realm may never have been gifted tales such now-timeless as 'The Little Mermaid', 'The Emperor's New Clothes' and 'The Ugly Duckling'.

*

Born in Odense, the third largest city in Denmark, on Tuesday 2nd April 1805, Andersen was the only son of a sickly, 22-year old shoemaker and his older wife. His family were virtually penniless, and Andersen grew up in a one-bedroom house in Odense's poorest quarter. In his youth, he attended school sporadically, and spent far more time memorizing and reciting stories than studying in

any traditional fashion. This propensity for storytelling, combined with the sudden death of his father in 1816, led to Andersen's mother deciding her eleven-year son needed to learn a proper, wage-paying trade. She sent him to apprentice as a weaver, after which he worked reluctantly in a tobacco factory and a tailor's shop.

In 1819, aged fourteen, Andersen travelled a hundred miles to the Danish capital Copenhagen to seek his fortune. However, his first three years were marked by extreme poverty and a string of failed financial endeavours. At first, having an excellent soprano voice, Andersen was accepted into a boy's choir, but when his voice began to break he was forced to quit. He then attempted to become a ballet dancer, but his tall, gangly body prevented him from finding any success. In desperation, Andersen even attempted manual labour – a style of work to which he had never been suited. During these three years, following advice given him by a poet he had met while singing in the choir, Andersen began to write, penning a number of short stories and poems.

In 1822, at the age of 17, Andersen's dogged persistence paid off, following a chance encounter with a man named Jonas Collin. Collin was director of the Royal Danish Theatre, and having read a number of Andersen's writings – including his first published story, 'The Ghost at Palnatoke's Grave' – felt convinced he showed promise. Collin approached King Frederik VI (1768-1839), and managed to convince the monarch to partially fund the young artist's education. (In recent times, various other theories pertaining to Andersen's royal connection have arisen, stemming from both

Andersen's father's firm belief that he possessed noble heritage, and the notion that Andersen himself may have been an illegitimate son of the royal family.)

Andersen began his education in the towns of Slagelse and Helsingor, on the Danish island of Zealand. However, despite receiving the finest schooling, he was an average student – possibly because he suffered from dyslexia – and was mocked by other pupils for his desire to become a writer. At one point, he lived at his schoolmaster's home, where he was physically abused. Andersen would later describe his time in school as the most unhappy period of his life. In 1827, his despair led Jonas Collin to remove him from school, and organise for Andersen to complete his studies in Copenhagen with a private teacher. In 1828, the 23-year old passed the required exams for entrance into the University of Copenhagen.

In 1829, during his first year of university studies, Andersen achieved his first notable literary success with a short story entitled 'A Journey on Foot from Holmen's Canal to the East Point of Amager'. During the same semester, he published a comedy and a collection of poems. Four years later, Andersen received a grant from King Frederik for travel expenses, and spent the next 18 months roaming through Germany, Switzerland, France and Italy – the last of which he was deeply fond. For Andersen, this trip began a lifelong infatuation with travel – over the course of his life he would embark on some thirty extended journeys, spending a combined fifteen years of his life in other countries. Indeed, aside from the fairy tales that would eventually cement his fame, Andersen was

renowned for his vivid travelogues, and is credited with having declared "to travel is to live."

In 1835, Andersen published his breakthrough piece of writing – an autobiographical novel titled *The Improvisatore*. An instant success, the book's detailing of rural Italy delighted readers all across Europe, and it was translated into French and German within two years of its publication. Also in 1835, Andersen published the first of his now-legendary fairy tales. Despite their modern status, these first efforts weren't immediate successes, being overshadowed by his next two novels, *O. T.* (1836) and *Only a Fiddler* (1837), and his *Scandinavianist* poem *I am a Scandinavian* (1840).

The fame of Andersen's fairy tales (revolutionary in the field of Danish children's literature) began to grow during the late thirties. Between 1835 and 1837, over three booklets, he published his first collection of stories, which included 'The Tinderbox', 'The Princess and the Pea', 'Thumbelina', 'The Little Mermaid', and 'The Emperor's New Clothes'. In 1838, he published his second series, *Fairy Tales Told for Children,* which consisted of 'The Daisy', well-known tale 'The Steadfast Tin Soldier' and 'The Wild Swans'. Over the next seven years, Andersen continued to regularly publish collections, the 1843 version of which included 'The Ugly Duckling' – cementing his reputation as a leading author of children's literature. Over the rest of his life, Andersen would go on to publish a total of more than a hundred and fifty fairy tales.

In 1838, the spectre of poverty was banished from Andersen's life forever, when King Frederick VI awarded him an annual stipend for life. By the 1840s, he was an internationally renowned author, celebrated across the continent for his apparently inimitable storytelling gift. During visits to Germany and England in 1846 and 1847 respectively, he was hailed as a foreign dignitary, and while in London he met Charles Dickens for the first time, returning some ten years later to stay at the writers' home for five years. In 1846, he received the Knighthood of the Red Eagle from King Friedrich Wilhelm IV of Prussia, and while in France he spent time with a number of famous artists, including Honore de Balzac, Alexandre Dumas and Victor Hugo. (Interestingly, however, in his native Denmark, the praise for Andersen's work wasn't quite so unanimous. Amongst others, the philosopher Søren Kierkegaard attacked his work for being naïve and fundamentally vacuous.)

Andersen spent many of the later years of his life penning well-received travelogues, including his acclaimed *Pictures of Sweden* (1851) and *In Spain* (1863). Meanwhile, despite a desire to build his literary reputation on more adult fiction, his *Fairy Tales* continued to appear in instalments, and to prove extremely popular with readers. The last batch appeared in the spring of 1872, a few weeks before Andersen fell out of bed and severely injured himself. Over the next couple of years, Andersen's literary output declined, and he developed liver cancer. He died on the 4th August 1875, while in the care of his friends in Copenhagen.

*

It is perhaps curious that a man who never married, and who never had any children of his own, managed to pen tales so well-tuned to the child psyche. Part of the explanation for this may lay in Andersen's own troubled life. For one, the Dane was denied anything like a proper childhood of his own, with his father dying when he just eleven and his mother forcing him into the world of manual work. Also, Andersen had an odd and in many ways childlike relationship with love and lust. A lifelong celibate, he frequently fell in love with unattainable women – his tale 'The Nightingale' was inspired by Andersen's unrequited love for opera singer Jenny Lind – and also experienced a number of unreciprocated passions for various men in his life. (Tales such as 'The Little Mermaid' and 'The Ugly Duckling' play deeply into themes of impossible love and poor self-image.) This self-imposed celibacy, combined with his apparently impassioned bisexuality, has caused much debate amongst Andersen's biographers. In 2011, a proposal by a number of Danish MPs to instigate a gay pride week in honour of the cherished national poet polarised national opinion.

As an interesting aside, it is worth noting that many of the popular English translations of Andersen's tales are said to lose much of the deeper – and, in many instances, darker – layers that they possess in the original Danish. The original tales are run through with existential and often pained themes; however, during the 1840s, many of Andersen's earliest translators simplified the language and bent the tales to suit strict Victorian ideals of moralism and civility, even going so far as to drastically alter features of the plot. It was due in large part to this that, in

Britain, Andersen's tales came to be viewed as simple, sentimental children's yarns – whereas on the continent they were viewed as much more complex pieces of work. As Andersen himself once stated, in talking about his creative process:

> I seize on an idea for grown-ups, and then tell the story
> to the little ones while always remembering that
> Father and Mother often listen, and you must also
> give them something for their minds.

Later, he complained about the reputation his work had garnered in Britain:

> I said loud and clear that I was dissatisfied...
> that my tales were just as much for older
> people as for children, who only understood
> the outer trappings and did not comprehend
> and take in the whole work until they were mature.

Ultimately, Andersen's tales – originally laced with comedy, social critique, satire and philosophy – have undoubtedly suffered, across various translations and adaptations, from a century and a half of emotional child-proofing. Indeed, no two pieces of work are more guilty of sanitising and sweetening Andersen's life and work than the sugary 1952 biopic *Hans Christian Andersen* and Disney's famous *The Little Mermaid* (1989) – which swapped Andersen's original ending (as contained in this collection) for one in which Ariel and Eric marry and live happily ever after.

However., the original tales, as contained here, remain stunning pieces of fantastic literature. Whatever the facts of Andersen's psychology and sexuality, and regardless of the existence of less-than-satisfactory translations, there is no doubt that Dane ranks with Aesop and the Brothers Grimm as one of the greatest authors of children's literature of all time. His stories have been translated into more than 150 languages – from Inupiat in the Arctic to Swahili in Africa – and have inspired almost countless adaptations (including as theme parks, in both Japan and China). "The Emperor's New Clothes" and "The Ugly Duckling" have both passed into the English language as well-known idioms, and. International Children's Book Day has been celebrated on the 2nd April – Andersen's birthday – since 1967.

Ultimately, however much he might have wanted to be taken more seriously as a writer of adult fiction, Andersen had an exceptional, mercurial relationship with his child readers; a relationship which lasted right up until the weeks before his passing, when he informed the composer writing the music for his funeral that "most of the people who will walk after me will be children, so make the beat keep time with little steps."

* * *

'The Princess and the Pea' was first published in May of 1835 in an unbound 61-page booklet called *Tales Told for Children: First Collection, First Booklet.* The source for the story had been much-debated: In his preface to the second volume of *Tales and Stories* (1863), Andersen claimed to have heard the story during

his childhood, but it is not part of traditional Danish folklore. It may be that, as a child, he came across a similar Swedish tale, called 'Princess Who Lay on Seven Peas'.

Like many of Andersen's early tales, 'The Princess and the Pea' was received harshly by critics, who viewed it as bizarre, morally ambiguous, and potentially insulting to royalty. Indeed, in its first (very poor) English translation, the story's lone pea was converted into a trio of peas in an attempt to make the story more credible. However, the tale has since become extremely well-known, and was adapted into a full-length animation film as recently as 2002.

M. M. Owen

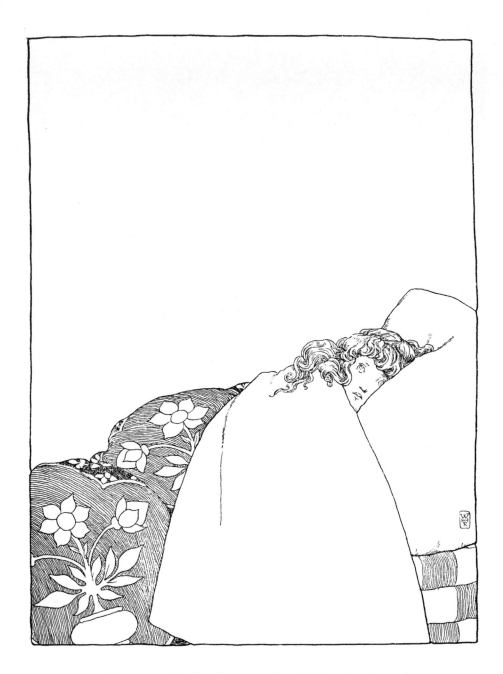

I have scarcely closed my eyes the whole night through

Introduction

to

THE GOLDEN AGE OF ILLUSTRATION

The 'Golden age of Illustration' refers to a period customarily defined as lasting from the latter quarter of the nineteenth century until just after the First World War. In this period of no more than fifty years the popularity, abundance and most importantly the unprecedented upsurge in quality of illustrated works marked an astounding change in the way that publishers, artists and the general public came to view this hitherto insufficiently esteemed art form.

Until the latter part of the nineteenth century, the work of illustrators was largely proffered anonymously, and in England it was only after Thomas Bewick's pioneering technical advances in wood engraving that it became common to acknowledge the artistic and technical expertise of book and magazine illustrators. Although widely regarded as the patriarch of the *Golden Age*, Walter Crane (1845-1915) started his career as an anonymous illustrator – gradually building his reputation through striking designs, famous for their sharp outlines and flat tints of colour. Like many other great illustrators to follow, Crane operated within many different mediums; a lifelong disciple of William Morris and a member of the Arts and Crafts Movement, he designed all manner of objects including wallpaper, furniture, ceramic ware and even whole

interiors. This incredibly important and inclusive phase of British design proved to have a lasting impact on illustration both in the United Kingdom and Europe as well as America.

The artists involved in the Arts and Crafts Movement attempted to counter the ever intruding Industrial Revolution (the first wave of which lasted roughly from 1750-1850) by bringing the values of beautiful and inventive craftsmanship back into the sphere of everyday life. It must be noted that around the turn of the century the boundaries between what would today be termed 'fine art' as opposed to 'crafts' and 'design' were far more fluid and in many cases non-operational, and many illustrators had lucrative painterly careers in addition to their design work. The Romanticism of the *Pre Raphaelite Brotherhood* combined with the intricate curvatures of the *Art Nouveaux* movement provided influential strands running through most illustrators work. The latter especially so for the Scottish illustrator Anne Anderson (1874-1930) as well as the Dutch artist Kay Nielson (1886-1957), who was also inspired by the stunning work of Japanese artists such as Hiroshige.

One of the main accomplishments of nineteenth century illustration lay in its ability to reach far wider numbers than the traditional 'high arts'. In 1892 the American critic William A. Coffin praised the new medium for popularising art; 'more has been done through the medium of illustrated literature… to make the masses of people realise that there is such a thing as art and that it is worth caring about'. Commercially, illustrated publications reached their zenith with the burgeoning 'Gift Book' industry which emerged in

the first decade of the twentieth century. The first widely distributed gift book was published in 1905. It comprised of Washington Irving's short story *Rip Van Winkle* with the addition of 51 colour plates by a true master of illustration; Arthur Rackham. Rackham created each plate by first painstakingly drawing his subject in a sinuous pencil line before applying an ink layer – then he used layer upon layer of delicate watercolours to build up the romantic yet calmly ethereal results on which his reputation was constructed. Although Rackham is now one of the most recognisable names in illustration, his delicate palette owed no small debt to Kate Greenaway (1846-1901) – one of the first female illustrators whose pioneering and incredibly subtle use of the watercolour medium resulted in her election to the Royal Institute of Painters in Water Colours in 1889.

The year before Arthur Rackam's illustrations for *Rip Van Winkle* were published, a young and aspiring French artist by the name of Edmund Dulac (1882-1953) came to London and was to create a similarly impressive legacy. His timing could not have been more fortuitous. Several factors converged around the turn of the century which allowed illustrators and publishers alike a far greater freedom of creativity than previously imagined. The origination of the 'colour separation' practice meant that colour images, extremely faithful to the original artwork could be produced on a grand scale. Dulac possessed a rigorously painterly background (more so than his contemporaries) and was hence able to utilise the new technology so as to allow the colour itself to refine and define an object as opposed to the traditional pen and ink line. It has been estimated that in 1876 there was only one

'colour separation' firm in London, but by 1900 this number had rocketed to fifty. This improvement in printing quality also meant a reduction in labour, and coupled with the introduction of new presses and low-cost supplies of paper this meant that publishers could for the first time afford to pay high wages for highly talented artists.

Whilst still in the U.K, no survey of the *Golden Age of Illustration* would be complete without a mention of the Heath-Robinson brothers. Charles Robinson was renowned for his beautifully detached style, whether in pen and ink or sumptuous watercolours. Whilst William (the youngest) was to later garner immense fame for his carefully constructed yet tortuous machines operated by comical, intensely serious attendants. After World War One the Robinson brothers numbered among the few artists of the Golden Age who continued to regularly produce illustrated works. As we move towards the United States, one illustrator - Howard Pyle (1853-1911) stood head and shoulders above his contemporaries as the most distinguished illustrator of the age. From 1880 onwards Pyle illustrated over 100 volumes, yet it was not quantity which ensured his precedence over other American (and European) illustrators, but quality.

Pyle's sumptuous illustrations benefitted from a meticulous composition process livened with rich colour and deep recesses, providing a visual framework in which tales such as *Robin Hood* and *The Four Volumes of the Arthurian Cycle* could come to life. These are publications which remain continuous good sellers up

till the present day. His flair and originality combined with a thoroughness of planning and execution were principles which he passed onto his many pupils at the *Drexel Institute of Arts and Sciences*. Two such pupils were Jessie Willcox Smith (1863-1935) who went on to illustrate books such as *The Water Babies* and *At the Back of North Wind* and perhaps most famously Maxfield Parrish (1870-1966) who became famed for luxurious colour (most remarkably demonstrated in his blue paintings) and imaginative designs; practices in no short measure gleaned from his tutor. As an indication of Parrish's popularity, in 1925 it was estimated that one fifth of American households possessed a Parrish reproduction.

As is evident from this brief introduction to the 'Golden Age of Illustration', it was a period of massive technological change and artistic ingenuity. The legacy of this enormously important epoch lives on in the present day – in the continuing popularity and respect afforded to illustrators, graphic and fine artists alike. The ensuing volumes provide a fascinating insight into an era of intense historical and creative development, bringing out of print books and their art back to life for both young and old to revel and delight in.

We hope that the current reader adores these books as much as we do. Enjoy.

Amelia Carruthers

THE PRINCESS AND THE PEA

nce upon a time there was a prince and he wanted a princess; but she would have to be a real princess. He travelled all round the world to find one, but always there was something wrong. There were princesses enough, but he found it difficult to make out whether they were real ones. There was always something about them that was not quite right. So he came home again and was very sad, for he would have liked very much to have a real princess.

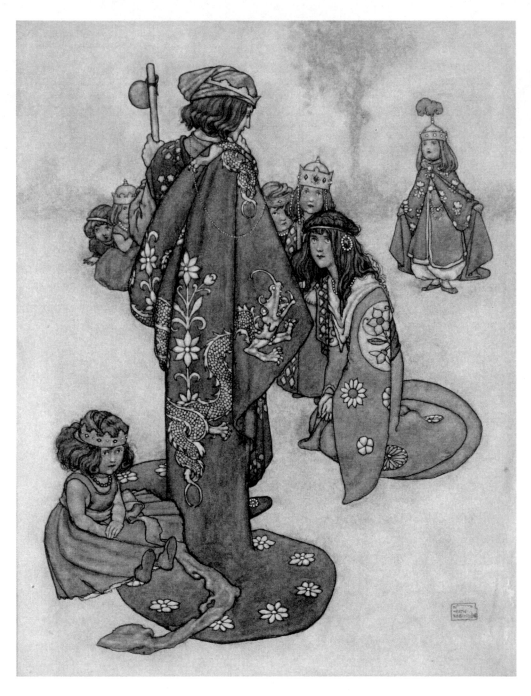

Princesses he found in plenty, but wether they were real Princesses it was
impossible for him to decide.

One evening a terrible storm came on; it thundered and lightened, and the rain poured down in torrents. It was really dreadful! Suddenly a knocking was heard at the city gate, and the old King himself went to open it.

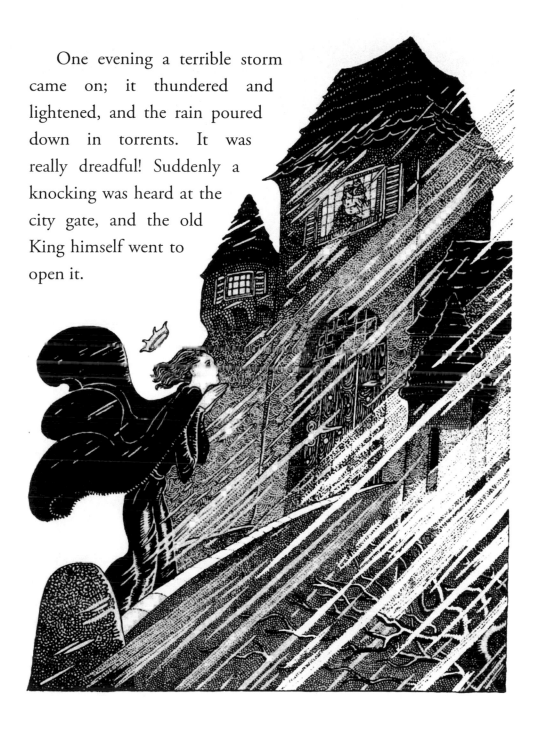

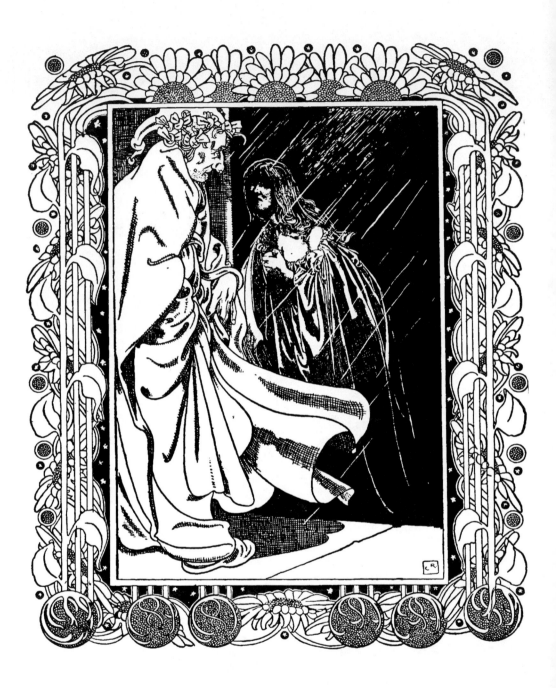

Somebody knocked at the town gate and the old king himself went to open it.

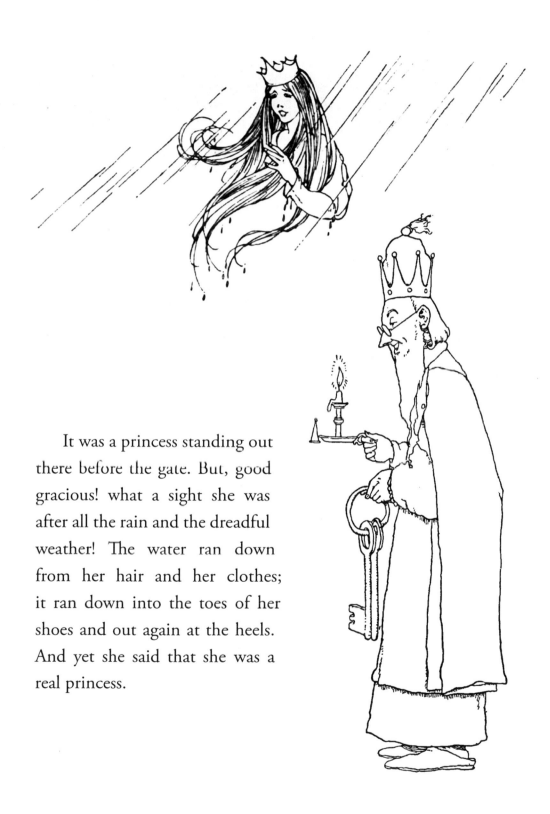

It was a princess standing out there before the gate. But, good gracious! what a sight she was after all the rain and the dreadful weather! The water ran down from her hair and her clothes; it ran down into the toes of her shoes and out again at the heels. And yet she said that she was a real princess.

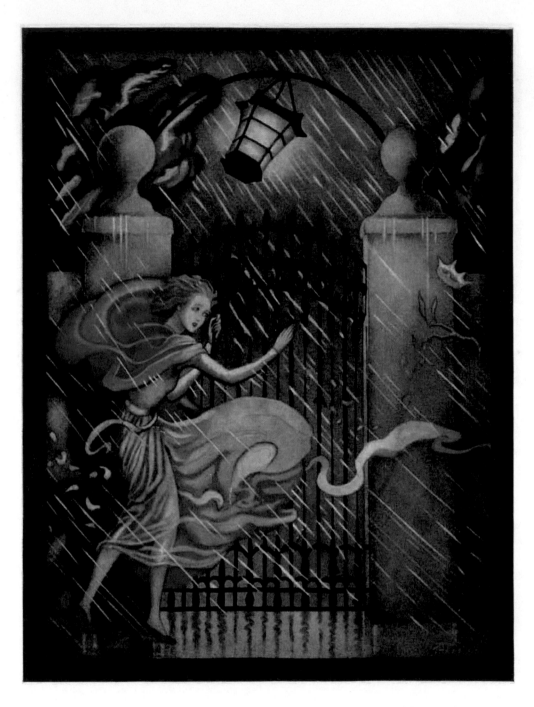

It was a princess who stood outside, but she was in a terrible state from
the rain and the storm.

"Yes, we'll soon find that out," thought the old Queen.

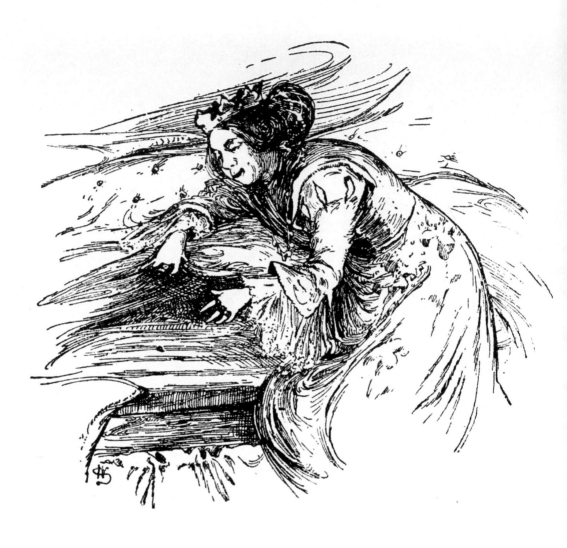

"Well, we'll soon find that out," thought the old queen. But she said nothing, went into the bedroom, took all the bedding off the bedstead, and laid a pea at the bottom; then she took twenty mattresses and laid them on the pea, and then twenty eiderdown beds on top of the mattresses.

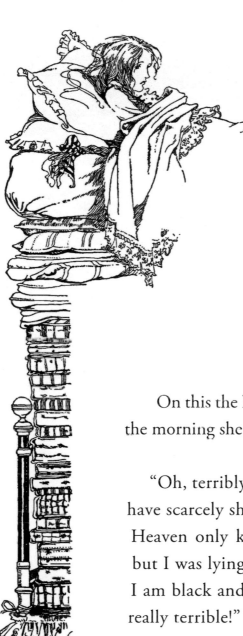

On this the Princess was to lie all night. In the morning she was asked how she had slept.

"Oh, terribly badly!" said the Princess. "I have scarcely shut my eyes the whole night. Heaven only knows what was in the bed, but I was lying on something hard, so that I am black and blue all over my body. It is really terrible!"

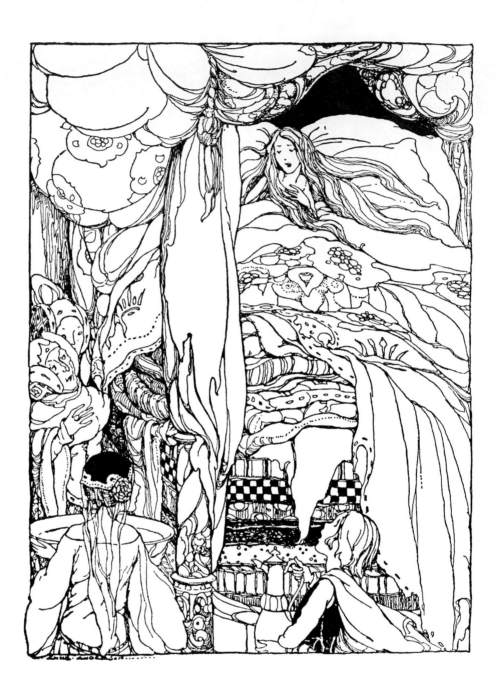

The next morning she was asked how she had slept.

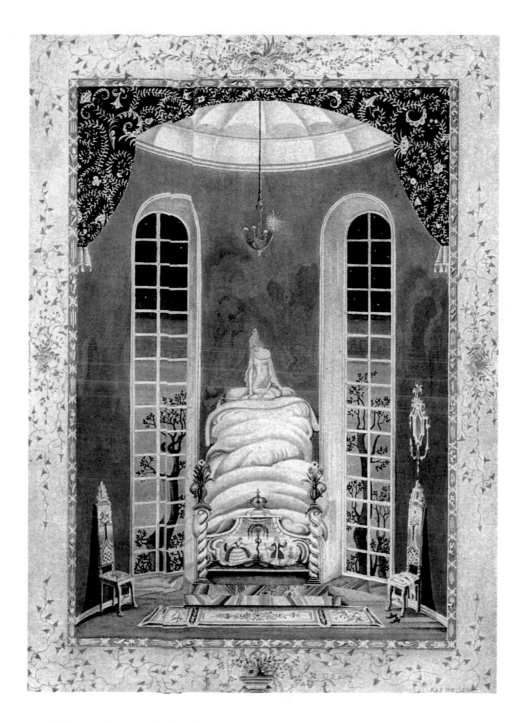

*"Oh very badly indeed!" she replied. "I have scarcely closed my eyes the whole
night through. I do not know what was in my bed."*

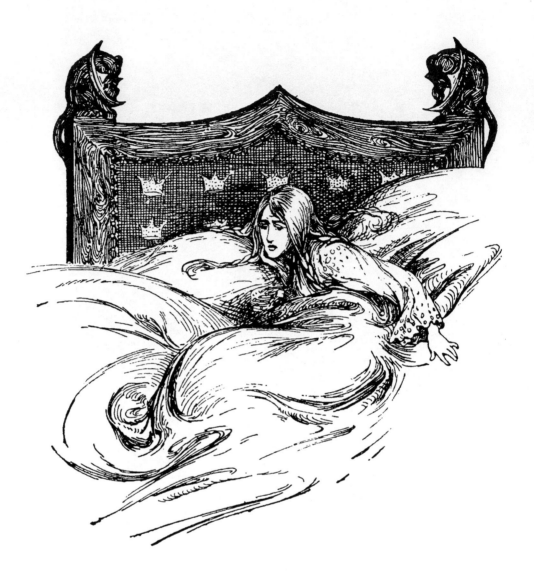

Now they knew that she was a real princess, because she had felt the pea right through the twenty mattresses and the twenty eiderdown beds.

Nobody but a real princess could be as sensitive as that.

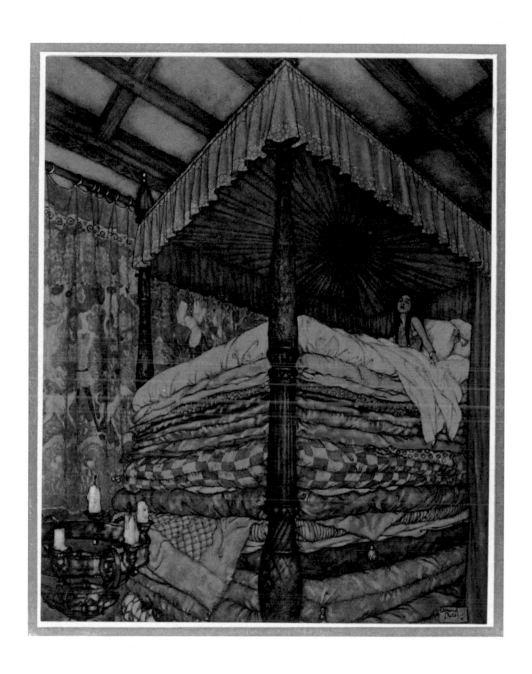

I have hardly closed my eyes the whole night! Heaven knows what was in my bed.
I seemed to be lying upon some hard thing, and my whole body was
black and blue this morning. It is terrible!

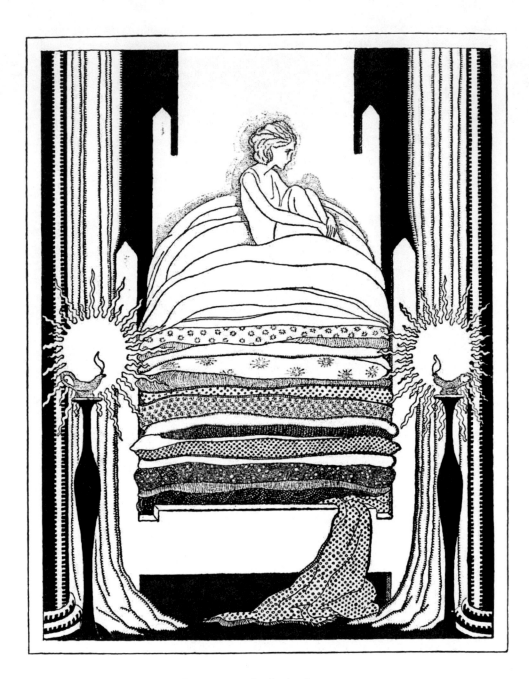

What was in the bed who can say!

So the prince took her for his wife, for now he knew that he had a real princess; and the pea was put in the Art Museum, where it may still be seen, if no one has stolen it.

There, that is a real story!

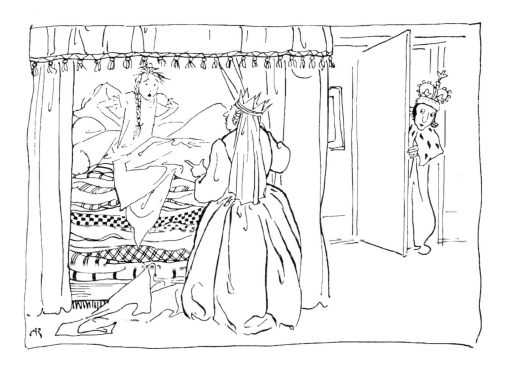

ILLUSTRATOR BIOGRAPHIES

Anne Anderson

Anne Anderson was born in Scotland in 1874. She spent her childhood in Argentina, where she became interested in illustration, before returning to Britain in her late twenties. In 1912, Anderson married Alan Wright. Wright was a painter who had previously been fairly successful, but whose commissions had dried up due to his association with a controversial Baron Corvo work he had illustrated in 1898. The two of them settled in Berkshire, and began to collaborate on a number of illustrated works.

Anderson was considered the driving force in the partnership, and her work quickly became extremely popular. Over the course of her life, she produced more than a hundred illustrated books, as well as etchings, watercolours and greeting cards.

Anderson's work has been compared to that of her contemporaries, such as Charles Robinson, Jessie M. King and Mabel Lucie Attwell. Here best-remembered illustrations are those she penned for works by Hans Christian Andersen and the Grimm Brothers. Anderson died in 1930, aged 56.

Honor C. Appleton

Honor C. Appleton was born in England in 1879. She started her illustrating career as a student of the Royal Academy Schools, and she went on to develop a distinctive and delicate watercolour style. Influenced by contemporary illustrators such as Arthur Rackham, Heath Robinson, Kate Greenaway and Annie French, Appleton illustrated over 150 books during the course of her career. Her most famous works are *Our Nursery Rhyme Book* (1912), Charles Perrault's *Fairy Tales* (1919) and Hans Christian Andersen's *Fairy Tales* (1922). Appleton died in 1951.

Maxwell Armfield

Maxwell Armfied was born in Ringwood, Hampshire, England in 1881. In 1887, he was admitted to the Birmingham School of Art – at that point under the headmastership of influential artist Edward R. Taylor – and was heavily influenced by the then-burgeoning Arts and Crafts Movement.

In 1902, Armfield left Birmingham for Paris, where he studied at the Académie de la Grande Chaumière. He exhibited at the Paris Salon in 1904, after which his painting *Faustine* was bought and donated to the National Museum of Luxembourg. Returning to London some years later, Armfield embarked on a series of one-man exhibitions, showing at the Robert Ross's Carfax Gallery, the Leicester Galleries and elsewhere.

Aside from painting, Armfield was a prolific illustrator and versatile decorative artist. He was also heavily involved in theatre, music, teaching and journalism, and wrote almost twenty books, including poetry, travelogues and textbooks. He died in 1972, aged 91.

Edmund Dulac

Edmund Dulac was born in Toulouse, France in 1882. He initially studied law at the University of Toulouse and the Académie Julian in Paris, before moving to London in 1904. Shortly after his arrival, the Frenchman won a commission to illustrate *Jane Eyre,* and under the ensuing relationship he developed with publishers Hodder & Stoughton, he illustrated editions of *Stories from The Arabian Nights* (1907), *The Tempest* (1908), *Stories from Hans Christian Andersen* (1911) *The Bells and Other Poems by Edgar Allan Poe* (1912), and many others.

Dulac became a naturalized British Citizen in 1912, and during World War I he contributed to a number of relief books, including his own *Edmund Dulac's Picture Book for the French Red Cross* (1915). After the war, his work spread into a number of other areas, including newspaper caricatures portraiture, theatre costume and set design, medals, and even postage stamps – including those issued to celebrate the coronation of King George VI (1937) and the 1948 Summer Olympics. Dulac died in 1953, aged 70.

Kay Nielsen

Kay Rasmus Nielsen was born in Copenhagen, Denmark in 1886. Hailing from an artistic family – his father was a theatre director and his mother was one of the most celebrated actresses of her time – Nielsen studied art in Paris between 1904 and 1911, before moving to England. He received his first commission in 1913, providing 24 colour plates and more than 15 monotone illustrations for *In Powder and Crinoline, Fairy Tales Retold by Sir Arthur Quiller-Couch.*

A year later, in 1914, Nielsen contributed 25 colour plates and a number of monotone images to the Norwegian folk tale *East of the Sun and West of the Moon.* During World War I, Nielsen worked on stage design, before turning to illustrated books once more with the publication of *Fairy Tales by Hans Andersen* (1924), to which he contributed 12 colour plates and more than 40 monotone illustrations. Many view this as some of Nielsen's best work. He followed it a year later with *Hansel and Gretel, and Other Stories by the Brothers Grimm.*

In 1939, Nielsen left for California, where he found work with The Walt Disney Company. Amongst other things, he designed the 'Night on Bald Mountain' sequence for the film classic Fantasia. However, Nielsen was let go in 1941, and the last decade or so of his life proved a difficult time, during which he struggled for paid work and eventually fell into poverty. Indeed, it wasn't until some time after his death in 1957, aged 71, that Nielsen came to be viewed as one of the notable figures of the 'golden age of illustration'.

Jennie Harbour

Jennie Harbour was born in approximately 1893, most likely in London, England. Despite the fact that she was a talented and popular illustrator, and her works are now collector's items, little is known about her life. During the twenties, Harbour worked for The Raphael Tuck Publishing Company, a renowned printer of popular books and illustrated postcards. A defining artist of the Art Deco era, her most famous work is probably *My Book of Favourite Fairy Tales* (1921), which featured twelve colour plates and numerous black and white illustrations. Harbour also illustrated editions of *Hans Andersen's Stories* and My Book Of *Mother Goose Nursery Rhymes.* She died during the fifties.

Arthur Rackham

Arthur Rackham was born in London, England in 1867. One of twelve children, he first studied at the City of London School, where he won a number of prizes for his art. At the age of 18, Rackham became a clerk in the Westminster Fire Office, and continued to study part-time at the Lambeth School of Art. Around this time, he began to make occasional sales to the illustrated magazines of the day, such as *Scraps* and *Chums*. In 1891, he developed a close association with the *Pall Mall Budget* as one of the weekly's main illustrative reporters.

Beginning in 1892, Rackham left his clerk position at the Westminster Fire Office for the uncertainty of a career as an illustrator. He quickly secured a regular job as a reporter and illustrator at the *Westminster Budget*, a weekly magazine. At this stage, Rackham's illustrations were quite naturalistic in style, owing much to artists such as Howard Pyle. In 1893, his first book illustrations began to appear, and in 1896, his first whole book completed specifically on commissions was published, entitled *The Zankiwank and The Bletherwitch*. It featured the first hints of the fantastical, Gothic style for which he was to become known.

Rackham completed nineteen more book assignments during the 1890s, and continued to produce work at a good rate into the 20th century. In 1905, his first major, notable work appeared – a stunning version of the Washington Irving classic *Rip Van Winkle,* featuring 51 colour plates. A year later, another 50-plate work, *Peter Pan in Kensington Gardens,* appeared. In 1907, Rackham illustrated an edition of *Alice's Adventures in Wonderland,* and a redux of his earlier *The Ingoldsby Legends* appeared. By now, he was a well-known name, and his illustrations quickly became sought-after pieces of art.

Over the course of the rest of his life, Rackham illustrated a multitude of other works, including Shakespeare's *A Midsummer Night's Dream* (1908), Friedrich de la Motte Fouqué's *Undine (*1909), Richard Wagner's *The Rhinegold* and *The Valkyrie* (1910), *Aesop's Fables* (1912), J. M. Barrie's *Peter Pan in Kensington Gardens* (1912), Charles Dickens' *A Christmas Carol* (1915), *Cinderella* (1919), Shakespeare's *The Tempest* (1926), Edgar Allan Poe's *Tales of Mystery & Imagination* (1935) and – what is now considered his classic children's work, along with *Peter Pan in Kensington Gardens* – Kenneth Grahame's *The Wind in the Willows* (1940).

Rackham's works appeared in numerous exhibitions, including one at the Louvre in Paris in 1914. He died in 1939 at his home in Limpsfield, Surrey, England.

Charles Robinson

Charles Robinson was born in Islington, London, England in 1870. The son of an illustrator, and the brother of famous illustrators Thomas Heath Robinson and William Heath Robinson, he served a seven-year apprenticeship as a printer and took art lessons in the evenings. In 1892, Robinson won a place at the Royal Academy, but was unable to take it up due to lack of finances.

It wasn't until the age of 25 that Robinson began to sell his work professionally. His first full book was Robert Louis Stevenson's *A Child's Garden of Verses* (1895). The work was very well-received, going through a number of print runs. Over the rest of his life, Robinson illustrated many more fairy tales and children's books, including Eugene Field's *Lullaby Land* (1897), W. E. Cule's *Child Voices* (1899), Friedrich de la Motte Fouqué's *Sintram and His Companions* (1900), *Alice's Adventures in Wonderland* (1907), *Grimm's Fairy Tales* (1910) and Frances Hodgson Burnett's *The Secret Garden* (1911).

Robinson was also an active painter, especially in later life, and was elected to the Royal Institute of Painters in Water Colours in 1932. He died in 1937, aged 67.

W. Heath Robinson

William Heath Robinson was born in North London, England in 1872. Hailing from an artistic family – his brothers Thomas Heath and Charles were both respected illustrators – he studied at both the Islington School of Art and the Painting Schools of the Royal Academy. Originally, Robinson wanted to make a living as a landscape painter, but by the age of 25 had switched his attentions to producing illustrations for the burgeoning printed publications of the day.

In 1897, Robinson began publishing his earliest book illustrations. In 1902, he had his first minor success with the popular children's book, *The Adventures of Uncle Lubin.* Two years, *Rabelais* was published, containing more than 250 of his black and white illustrations in the Art Nouveau style. This book launched Robinson's career, establishing him as a major and sought-after artist.

However, Robinson was still struggling for money – not least because the publisher of *Uncle Lubin* and *Rabelais* had gone bust before he got paid – and he turned to the most accessible source of immediate income he could find: humorous drawings for magazines such as *The Tattler, The Bystander* and *The Sketch.* Alongside this, Robinson continued to illustrate books, including editions of *Chaucher* (1905), *The Iliad* (1906) and *The Odyssey* (1906) – the three of which were a

Over the next few years, Robinson produced a number of the full-colour gift books for which he is well-remembered, including editions of Twelfth Night (1908), The Collected Verse of Rudyard Kipling (1909) and Bill the Minder (1912). He also continued to produce series of humorous drawings poking fun at ordinary living. Many of these featured highly complicated mechanical contraptions carrying out an extremely uncomplicated task with great effort – hence a "Heath Robinson" existing as a common idiom for complex inventions which produce absurdly simple results. The drawings were published in book form over a period of thirty years.

Robinson produced his autobiography, My Life of Line, in 1938. He died six years later, aged 72.

Helen Stratton

Helen Stratton was born in London, England in 1892. She began painting at a young age, but it was for her work as an illustrator that she would eventually become best-known. Strongly influenced by the Art Nouveau school of Glasgow, over the course of her career, Stratton illustrated at least five editions of Hans Christian Andersen's fairy tales, an edition of Grimm's Fairy Tales (1903), and Stories from Andersen, Grimm and the Arabian Nights (1929). She also painted watercolour illustrations for George MacDonald's The Princess and the Goblin and The Princess and Curdie. Stratton died in 1925, aged just 32.

Material in this book has been sourced from the following titles:

Thomas, Charles, and William Robinson, Illustrators.
Fairy Tales from Hans Christian Andersen. 1899
Helen Stratton, Illustrator. *Fairy Tales of Hans Andersen.* 1899
Maxwell Armfield, Illustrator. *Faery Tales from Hans Andersen.* 1910
Edmund Dulac, Illustrator. *Stories from Hans Andersen.* 1911
W. Heath Robinson, Illustrator. *Hans Andersen's Fairy Tales.* 1913
Kay Nielsen, Illustrator. *Hans Andersen's Fairy Tales.* 1924
Anne Anderson, Illustrator. *The Hans Andersen's Fairy Tales, Part 1.* 1924
Honor C. Appleton, Illustrator. *Fairy Tales by Hans Christian Andersen.* 1922
Jennie Harbour, Illustrator. *Hans Andersen's Stories.* 1932
Arthur Rackham, Illustrator. *Fairy Tales by Hans Christian Andersen.* 1932

Made in United States
North Haven, CT
02 November 2021